IMAGES
of America

HUTCHINSON AND
RENO COUNTY

D1618836

Published in 1918, this map shows Reno County as it appeared at that time. Little has changed since then. The railroads are now owned by Union Pacific and BNSF but are still operated on the same lines. Only the southern line passing through Castleton and Pretty Prairie has been decommissioned. There are several towns of note that have been lost to time, such as Lerado and Olcott. This map is contemporary to many of the photographs in this book. (Courtesy of Reno County Historical Society.)

ON THE COVER: The Reno House was the first hotel built in Hutchinson, Kansas. It was on the northwest corner of First Avenue and Main Street. From 1871 to 1913, this hotel saw countless thousands pass through its doors. This photograph, taken in 1887, shows a small sample of the patrons staying there. Whether they were coming to stay or just passing through, all of these people made their mark on Reno County. (Courtesy of Reno County Historical Society.)

IMAGES
of America

HUTCHINSON AND RENO COUNTY

David Reed
Foreword by Steve Harmon

ARCADIA
PUBLISHING

Published by Arcadia Publishing
Charleston, South Carolina

Printed in the United States of America

Library of Congress Control Number: 2022943544

For all general information, please contact Arcadia Publishing:
Telephone 843-853-2070
Fax 843-853-0044
E-mail sales@arcadiapublishing.com
For customer service and orders:
Toll-Free 1-888-313-2665

Visit us on the Internet at www.arcadiapublishing.com

Dedicated to all Reno County residents who have dared to dream, pushed the limits, and created this unique and wonderful Kansas county.

CONTENTS

Foreword 6

Acknowledgments 7

Introduction 8

1. Street Level 11

2. Education, Religion, and Government 33

3. Hotels and Banking 69

4. Amusement 77

5. Individual Enterprise 89

6. Salt, Grain, and Rail 109

About the Organization 127

FOREWORD

I have always been interested in history, especially that of Hutchinson. My great-grandfather moved to Hutchinson in 1911 from Ness City, Kansas. My family owned a furniture store in the downtown area for 60 years. I have always been the family curator of our historic photographs. About 20 years ago, I started collecting photographs of Hutchinson buildings, businesses, and events. Then I researched those photographs to better understand their history. Sometimes it has been a real challenge to get people to allow me to scan their family history archives. It is also imperative to get these items before the owners pass, because after that it becomes very hard to acquire or it gets thrown in the trash and lost forever.

I have eventually migrated into becoming the unofficial Hutchinson historian. I have had many longtime residents thank me for doing this because someone needs to carry on the process. The collection has now grown to about 5,000 images. I also started a weekly article about seven years ago in the newspaper and on Facebook, telling and showing what things looked like back then versus now, which has become very popular. I really enjoy interviewing my elders while they are still around because once they pass, their stories are lost forever.

Hutchinson has always been a rather unique place. It seems that those with a direct lineage to this place have always been the ones to promote proudly what has been accomplished here, from just a stop on the Santa Fe Railroad to the home of folks who have tried to make it "their special place." For the last 150 years, everything has happened here, and I'm proud to have been part of it for my 70 years.

About five years ago, I met David when he became head curator of the Reno County Museum. Because of our mutual interests in city photographs and history, we have become very good friends. We also depend on each other for information and accuracy. He has always impressed me with his ability to research newspaper archives and locate properties on historical maps and current Google maps. I cannot think of a better person to do a book on the very thing I love the most.

—Steve Harmon

ACKNOWLEDGMENTS

I could not have done this book without the encouragement and support of my colleagues at the museum, Katie, Thomas, and Ceeley. These people do the work of twice as many, and they do it with a passion that should make other museums envious.

All photographs in this book are courtesy of the Reno County Historical Society.

INTRODUCTION

Following the close of the Civil War, westward expansion began anew. By 1870, US Geological Survey (USGS) teams arrived in south central Kansas and began to plat the land that would become Reno County. They found a land barren of many of the vital resources needed for immediate settlement. In section after section, the teams noted there were no trees and no stone. Even the Osage, who had possession of this part of Kansas, did not live in the area year-round. The USGS teams noted the rivers and unremarkable soil and continued west.

The Atchison, Topeka & Santa Fe Railroad (ATSF) had ambitious plans to make its mark across Kansas and began racing west and eventually into the southwestern United States. Arriving on the banks of the Arkansas River with the railroad in 1871, Clinton Carter Hutchinson saw an opportunity. He had been a preacher, an agent for the Ottawa Tribe, and finally a land developer. His days with the Indians had been numbered following some allegations of missing federal funds, but he had managed to make strong connections with government officials in Topeka and so headed west.

In 1871, the first town in Reno County was platted and named after Hutchinson. As the railroad continued on, he stayed and oversaw the expansion of a new empire. For the next 15 years, farmers began to disperse throughout the county. Over 1,000 Civil War veterans, eager to take advantage of their 160-acre allotments, began to homestead. Merchants rushed to make their mark on a new economy. Reno County had the typical start for the average Kansas county.

All of that changed in 1887 with the accidental discovery of salt by Ben Blanchard. But Blanchard was not interested in salt and could not have predicted the industry that would arise from his discovery. Blanchard moved on to other endeavors, but word spread quickly of the massive, 99-percent pure vein of salt that he had discovered under the surface of the county. Within 10 years, Reno County was experiencing a salt boom with over a dozen factories built around Hutchinson. This immense growth led to the town receiving the moniker "the Salt City." At the start of the 20th century, through consolidation and attrition, only three companies remained and continue to produce salt to this day. The discovery of this deposit across southern Kansas insured that Reno County would always have a vital place in the Kansas economy.

The county was also one of the few in Kansas not truly dedicated to the cattle trade. The major cattle trails often skirted the eastern and western borders of the county but never came through. Farmers on the margins of the county found selling fresh produce to the passing cowboys was more profitable than selling grain. Cattle towns often had a reputation for being rambunctious and lawless. With this in mind, the founding members of the county originally made it dry and prohibited the free-range grazing of cattle within its borders. The relative calm and law-abiding citizens made it an attractive place to live.

The central location to the Kansas wheat fields and the booming salt industry made this a prime location for the railroads. The ATSF helped found the city of Hutchinson, but over the next 20 years, two more lines came in. It was unusual to see a frontier town with three rail lines.

There were plans for at least four more routes to come through the county, but railroading is a tumultuous business, and with mergers and bankruptcies, this never came to fruition.

For 150 years, Reno County has tried its hand at almost everything. Every conceivable type of manufacturing has occurred in the county, from automobiles and airplanes to farm machinery and storage tanks. Agriculture endeavors have included orchards and vinegar to pigs and dairy. Reno County boasted one of the largest zoos in the state for nearly 30 years and has been the home of the Kansas State Fair for over 100 years. Presidents and celebrities have walked the streets of the towns here. Even the Great Depression could not bring down the county.

By 1890, Reno County was firmly settled, and the towns that exist today were all founded by then. The story of this small section of Kansas has had twists and turns and unexpected outcomes. The pages within this book tell only a small part of that story. One thing that became clear during this process was the amount of material that has been produced throughout the county. Nearly every community has produced a historic record. Every town, regardless of size, had at least one newspaper. The individual involvement in the community is truly astounding and pays tribute to the level of devotion people here have to the place they call home.

The inspiration to write this book came from Pat Mitchell, a true renaissance woman who was an artist in every medium imaginable. She could sculpt, paint, sing, and write. Pat also had a passion for history. She collected it, recorded it, and recited it. Pat was an ardent believer in the preservation of history and found herself in the center of any such project in Hutchinson. In 1982, she wrote a two-volume book covering the history of Reno County through postcards. They were incredibly popular, and both volumes sold out very quickly. When Pat died in 2001, her private collection of over 10,000 items was donated to the Reno County Museum. She was meticulous in her organization and collecting methods, which has made the effort of preserving her work that much easier. The goal of this book was not to replicate and repeat Pat's work but to build on her example and show more of Hutchinson and include other areas of the county. Residents of Reno County should be proud of their historical heritage, and the state should be impressed with what it has accomplished in 150 years.

One

STREET LEVEL

The Queen City Meat Market was on the northwest corner of Fourth and Main Streets between 1906 and 1910. In the background, the 70-foot-tall spire of the Lutheran Church on Fifth Avenue can be seen. The streetcars in this photograph are just a few of the interurban line that operated from 1906 to 1930. Curiously, half of the cars in this image show their route to be "Ave A to Reformatory." Created by salt tycoon Emerson Carey, the interurban had 25 miles of track all over town at its peak. The rise of the automobile and the 1929 city flood proved to be the demise of the interurban.

McBurney Dry Goods moved into this building at Second Avenue and Main Street in 1905. McBurney retired in 1912 and sold his business to Pegues and Wright, who moved to a new location a few years later. The tall building just right of center is the Hutchinson Opera House. It was torn down in 1912 to make way for the Rorabaugh-Wiley Department store. During demolition, the contractor was asked how much of the building would be recycled. He replied by picking up a brick and crushing it to dust with one hand. The building was in such poor condition that little could be salvaged.

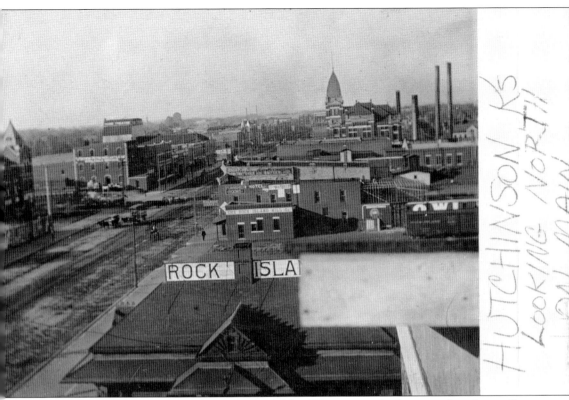

HUTCHINSON KS
LOOKING NORTH!!
ON MAIN

Overlooking Main Street at Avenue D, the Rock Island Depot is in the foreground, and partially out of frame is the Missouri Pacific Depot. Just to the right of this depot is the oldest building in Hutchinson. It started as a mill, but over the last 140 years it has played numerous roles for various businesses. The tall Romanesque spire of the Reno County Courthouse (1900–1925) is recognizable, as are the Carey Salt Plant stacks just to the right.

This aerial view of Hutchinson dates to 1941, the county's 70th anniversary, and the majority of the downtown area is featured. Many of the buildings featured in this photograph can be seen in greater detail elsewhere in this book. The Reno County Courthouse, Wiley Building, First National Bank, Stamey Hotel, and the Hutchinson Power Plant all appear prominently.

SOUTHWEST VIEW FROM ROCK MILL ELEVATOR, HUTCHINSON, KANSAS.

The Rock Mill Elevator (the vantage point for this image) was built in 1904 at the corner of Third Avenue and Poplar Street. Its location at the north end of town was close to the suburbs of Hutchinson at that time; thus, this view encompassed most of Hutchinson. At the time of its construction, the mill was the tallest structure in town at 114 feet. It burned to the ground in 1922. The other tall building in this photograph is the First National Bank.

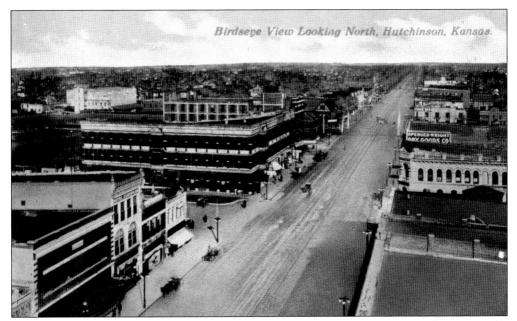

The photographer is facing north at the intersection of Main Street and Second Avenue. The focus is the Midland Hotel, which stood on the northwest corner of the intersection for 40 years before being replaced by the Wolcott office building. The Wolcott stood for 50 years before it too was demolished. Today, the corner is DCI Park.

ELKS HOME HUTCHINSON Ks

As early as 1904, the Elks Club began making plans to build a lodge. Prior to that, they were renting space where they could. The Elks Home was built in 1908. Originally, the club had planned to build on First Street and later decided to move to the southwest corner of Second Avenue and Walnut Street. The building stood until 1960, when it was razed and replaced with a newer lodge the following year.

The I.O.O.F. Temple, Hutchinson, Kansas. 11818 C. U. WILLIAMS PHOTO: IG BLOOMINGTON, IL

This building was completed at 100–102 West Sherman Street in 1909 and was the location for the Odd Fellows Temple. The Eaton Auto Company leased the first floor, selling Studebakers. By 1915, it had moved to a location on South Main Street, and Helm's Electric moved in. The building stood until at least 2000, but today the site is a parking lot.

In this image of Cow Creek, Bennett & Sons Bottling Plant at 122 West Avenue A is visible on the left. A Civil War veteran, Capt. William Bennett began his career in the bottling industry in Pennsylvania in 1866. In 1888, he relocated to Hutchinson and stayed in the bottling industry for over 50 years before retiring. His first drink was a lactose tonic, but he branched out into ginger ales, mineral water, all types of sodas, including Coca-Cola, and a specially formulated lemon beer. At one time, there were over 20 different manufacturers in Hutchinson producing sodas and beers, all needing to be bottled.

The 1929 flood was one of the worst disasters to occur in Reno County. On July 13, ten inches of rain caused Cow Creek to overflow its banks and flood almost all of downtown Hutchinson. While there was no loss of life and the water receded within two days, the damage to the town exceeded $3 million (nearly $20 million today). This flood motivated city officials, businesses, and citizens to champion better flood control in and around the town. Unfortunately, it took another flood and more than 20 years before flood control systems were finally put in place.

The movie *About Face* on the marquee of the Fox Theater dates this photograph to 1952. The Fox was built in 1931 and underwent a multi-million dollar restoration in the 1990s funded by an outpouring of community support to keep the theater alive. The Fox continues to operate today and is listed in the National Register of Historic Places. Next door was the Hollywood Grill, owned and operated by Gus Leonida, a World War I veteran who personally sold more war bonds than another other American during World War II with sales in excess of $10 million.

No other event in Reno County history has been more documented with photographs than the flood of 1929. This photograph was taken at the corner of Sherman and Main Streets. The man in the center is sitting on one of the concrete benches used for the streetcars that ran up and down Main Street. The only notable business to suffer severe damage was the Home Theater on Main Street and Avenue B. Flood waters caused the back of the building to collapse. It was irreparably damaged and torn down the next year.

The Richards-Scheble Candy Factory burned to the ground on July 3, 1911. Although firefighters arrived quickly to battle the blaze, low pressure from the water mains made it impossible to extinguish the fire. Luckily, insurance covered the cost, and the factory was quickly rebuilt. Following a petition by the Retail Merchants Association, Mayor Frank Vincent put forth a $20,000 bond to buy more equipment, update the water mains, and build another fire station to provide better coverage for the town. The bond passed by a narrow margin in January 1912

MAIN STREET LOOKING NORTH HUTCHINSON, KAN. 75.

Looking north down Main Street at First Avenue, this was Hutchinson in the 1950s. In the center is the Bank of Commerce building. Franks was a women's fashion store that started business in 1914 and lasted until 1975. To the right is Greenwalds. This location has the unlucky distinction of catching on fire twice. It first burned in 1939; the second time, in 1971, the fire took the lives of two Wiley's department store workers. The lot was razed, and today it stands empty.

H-3574 Soldiers' Monument, Hutchinson, Kansas.

The intersection of Walnut and First Streets is surrounded by important buildings. Built as an office building in 1911, the Hoke building is on the southwest corner and has recently been listed in the National Register of Historic Places. At the intersection is the Soldiers and Sailors Monument, dedicated to Civil War veterans in 1919. Abraham Lincoln stands at the top, surrounded by figures of a sailor, cavalry, infantry, and artilleryman, with two captured Confederate cannons. During World War II, they narrowly avoided destruction during a scrap metal drive. In 1997, the monument underwent a renovation and was also listed in the National Register.

This is Company E of the 2nd Regiment of the Kansas National Guard, which kicked off the Fourth of July parade in 1896. Company E was mustered into service in 1890 and deployed once to Greensburg to help protect a murder suspect from mob violence and another time to Seward County following the county seat "war" in 1892. The members were all mustered out in 1898.

Company E of the Kansas National Guard is seen in a parade on May 12, 1910. In the days leading up to Memorial Day, drill competitions were held. Company E of Hutchinson placed first, and Company F of Larned, Kansas, placed second. The newly built Elks Lodge is in the background, while the Baldwin Hotel is to the right. Notice the horse-drawn cart with the sign "baggage" on the side. Today, the Plaza Tower on Second Avenue and Walnut Street sits at this location.

The Diamond Pow Wow celebration marked the 75th anniversary of the founding of Reno County. Events lasting several days were planned all over the downtown area. This photograph was taken on May 16, 1946, on the first day of the celebration. The crowd in this image turned out to watch the Tune Wranglers perform on First Avenue next to the Wiley Building. Although hard to make out, the flags that decorated the stage are visible just left of center.

In 1906, Emerson Carey took over the Hutchinson Interurban and quickly sold off the horses and old street cars and replaced them with electric. By the fall of that year, the new Hutchinson Interurban was inaugurated, as this photograph commemorates. At its height, it was operating over 10 miles of track with stops all over town. As a result of women's fashions, there was a rash of accidents involving women that prompted the interurban to teach people how to board street cars.

This 1910 view of McBurney's Dry Goods shows the side of the building where a pushed-in section is visible. This was a skylight that provided natural light to the McInturff Portrait Studio. The Baldwin Hotel is at left. Originally built in 1878 as the Howard House, it was renovated in 1905 and renamed the Baldwin. It was one of the first hotels to install phones in some of its rooms. In 1932, it was renamed the Midland by Ed Colson, who renovated it to look like the old Midland Hotel on Main Street. It finally closed in 1951.

C.W. Mason operated the Cottage Grocery at the northeast corner of Avenue F and Plum Street around 1905. He is likely the man in the long white apron in front of the business, and the two boys carrying groceries are probably his sons. In 1932, Mason was still in the grocery business. That year, while on vacation at Lake of the Ozarks with friends, their boat ran out of gas. Mason volunteered to get gas from a local store. In the dark, he fell into the lake and drowned. His wife, Anna, who "had been in ill health," according to the *Hutchinson News*, "the shock of her husband's tragic death prostrated her for some time," and she died just three months later.

Pegues-Wright Dry Goods Store, Hutchinson, Kansas.

Lindsay Pegues and Oliver Wright arrived in Hutchinson from Junction City, Kansas, in 1911 and bought out McBurney's Dry Goods. In 1915, they moved the store from First and Main Streets to this location at Second and Main Streets, where it would stay for nearly 70 years. In 1952, the front of the building was drastically altered to its present appearance. Included in this new façade is a 10,000-piece wheat sculpture designed by Bernard Frazier and Elden Teft from Kansas University. The Wells-Fargo building to the right was erected in 1902, and by 1920, the company had vacated the building; today, it is a restaurant.

INTERNATIONAL HARVESTER COMPANY OF AMERICA, HUTCHINSON, KANSAS.
Mirror Print

The construction of the International Harvester Company Building at 4 West Avenue D was of great interest to Hutchinson. At 45,000 square feet, it was the largest non-grain building in the county. It took 600,000 bricks, 40 railcar loads of stone, and 26 cars of lumber. Built in only two months in 1904, it had hot water and a telephone system, considered modern conveniences at the time. Such was the demand for harvesting equipment in Kansas, rail lines were extended to the factory before construction was even complete. During World War II, the company moved out of this building to the Kirk Building at 106 West Second Street. This original building still sits on the northeast corner of Avenue D and Washington Street.

The Reno Buick Company leased this location from Delos Smith at 101–103 West First Avenue in 1922. In 1923, "Hi" Heaps said the company had its best month in five years, and just four months later, Reno Buick was bought by Topeka-based Wood-Hereford Motors. After it moved from this building in 1926, Delos Smith renovated it. The *Hutchinson News* reported, "He has cut the building down from a three-story building to a story and a half which makes it conform to the building . . . to the west." A keystone is still embedded in the façade that reads, "D.V Smith 1926."

Although James Franklin "Frank" Colladay was only passing through Hutchinson in 1885, he saw a booming city and quickly entered the hardware business. In 1908, he consolidated his two stores and constructed this building on Second Avenue and Plum Street and operated his wholesale business solely from here. In 1909, he constructed another building next door that operated as a saddle shop. Serving customers throughout western Kansas, the company sold virtually everything from blacksmithing equipment and harnesses to plumbing parts and hand tools. Colladay Hardware is still in operation today, though it vacated this building in 2005.

The Holdeman Motor Co
101-3 5 E Sherman St Hutc

Holdeman Motor Company opened at this location in 1909. The large banner on the side of the building advertising the Ringling Brothers Circus and the date—Friday, September 9—shows this photograph was taken in 1910. The truck decorated in flags and flowers and the multitude of flags around the building show that Holdeman was preparing for the Fourth of July parade that year. At right are the street sprinklers that were contracted by the city to help keep down dust on the numerous unpaved streets. They were probably used in the parade.

There are conflicting stories on how Abbyville got its name. The most likely one is that the town was named after the wife of the then-president of the ATSF, William Barstow Strong. This was Main Street looking due south from the railroad tracks sometime prior to 1908. The building just right of center with the four-square windows is the White Cottage Hotel. The home at the end of the street belonged to John Parker Dunn, a Civil War veteran of Company C, 9th Iowa. Arriving in 1874, he was one of the first settlers in Reno County. A fire in 1908 destroyed most of the buildings on Main Street. Ira McSherry did not rebuild his hardware and implement store and instead moved to Arlington.

The photographer is facing due south on Main Street in Partridge, Kansas. In the distance sits the Davis Grain Company elevator on the Rock Island line. The two-story white building on the right is the Partridge House, the town's hotel built in 1903. The large dark brick building next door stood at the corner of Main Street and Avenue F. The top floor was a large open space for community events and was named Stahly Hall for Moses Stahly, who constructed the building in 1901. The white two-story house on the left belonged to Elijah Hewitt, a Civil War veteran who lived in Partridge for about 10 years before relocating to Hutchinson in 1905.

Oil Fields near Hutchinson, Kansas

This dramatic photograph of oil fields seems more at place in Oklahoma or Texas. Oil prospecting around Arlington started in the early 1920s. On March 25, 1927, the first successful well was dug near Abbyville. In the months after, wells began to spring up all over central and northwestern Reno County. Throughout the 1930s, over 700 wells were drilled. The oil production of other counties has decreased the necessity for drilling in the county over the years. However, as of 2021, Reno County has produced over 110 million barrels of crude oil, with over 4,900 wells drilled.

Alexander Morris Switzer took the place of his father and enlisted in the Union army at the age of 16. After serving in the 85th Ohio Volunteers Regiment, he settled in Reno County in 1872, becoming one of the first settlers in the county. He sold his farm in 1905 and bought this store on the Missouri Pacific rail line. The following year he platted the land around his store, and Yoder, Kansas, was born. Switzer organized the bank and had the township renamed from Lincoln. He operated his store at the corner of Lawrence and Main Streets until his death at 70 in 1919.

These simple sod and brick structures were common throughout the county. Early surveys by the USGS show that the entire area was almost completely devoid of trees. The title says this was an "Old Stage Barn," which probably refers to its use on the Hutchinson, Kingman & Medicine Lodge stage route. Though it probably served many uses throughout its existence. While its exact location has been lost to time, it most likely was near the rail lines in Castleton.

This aerial view of Haven, Kansas, was taken around 1910 from the top of the mill on Second Street and Kansas Avenue. The photographer is looking due north down Kansas Avenue. The dark two-story building is the bank at the corner of Main Street and Kansas. In the distance is the Methodist church one block down on Fourth Street. In an interesting bit of continuity in the history of transportation, the harness and livery building in the foreground became the site of Shep Chevrolet for many decades.

ew from mill Haven Kans.

This photograph of Haven was taken slightly earlier than the previous one, probably closer to 1908. The nearest intersection is to the northeast and is the corner of Sedgwick and Main Streets. The Congregational church is at center. On the left is a horse-drawn thresher. The large building on the horizon to the left was the second school built in Haven. It was built in 1904 and burned down in 1908. Haven has built schools on this spot since the founding of the town.

Darlow was due south of Hutchinson on the ATSF railroad line. This line ran through the town to Castleton, Pretty Prairie, Kingman, and Medicine Lodge. Darlow peaked at 75 people around 1915, but by mid-century, much of it was gone. It is now one of over 70 ghost towns throughout Reno County.

This photograph was taken by the Charles Slack Company, which began business in 1905. By 1909, the company had traveling photographers across the Great Plains. Daniel Fair started his lumber company in 1884 in Sterling, Kansas. Within 20 years, he had branched out into over half a dozen different towns, including Partridge, Kansas. Opening in 1890, the lumber mill was on Main Street near the Santa Fe line where the present-day co-op now sits. Partridge is one of only three towns in Reno County to boast two rail lines today, the BNSF and Union Pacific.

Two

EDUCATION, RELIGION, AND GOVERNMENT

Construction for United Presbyterian Church began in late 1921 at Sixth Avenue and Elm Street, but because of various issues with the glass windows and pews, the church was nearly three months behind schedule when it opened for services on April 2, 1922. The building was recognized by the National United Presbyterian organization for its architectural style. The group even requested the architects come to its headquarters in Pennsylvania to see about making this a standard design for its churches. By 1971, the church had moved on from this location.

First Christian Church was built in 1885 at Fifth Avenue and Main Street. In 1908, it was sold to First United Brethren Church and moved to Fifth Avenue and Walnut Street. It was torn down in 1925 and replaced by a brick structure.

Haven Congregational Church was formed in 1883, almost three years before Haven was incorporated as a town. In 1893, the charter members voted to build a permanent church structure. Within six months, the church was built on the northeast corner of Main and Sedgwick Streets. The building has been modified over the years, such as removing the top half of the steeple and the addition of a basement, but it is still standing and still recognizable.

The First Baptist Church was among the first churches chartered in Reno County. This building was the third location for the congregation and was completed in 1888 at 226 East First Street. Sixteen years later, the church burned and had to be rebuilt. In May 1925, the building burned down again, and the church moved to a new location at Eighth Avenue and Main Street.

This incarnation of the First Christian Church was one of the largest churches in Hutchinson. Built on the southeast corner of Fifth Avenue and Main Street in 1909, the building served the members until 1970, when it was razed. It was determined that the costs to bring the building up to code and the excessive number of stairs inhibited renovation of the structure. A new and larger church was built just to the east, and this location was turned into a parking lot for the congregation.

First Methodist Church has stood on the corner of First Avenue and Walnut Street since 1875. In 1871, it became the first church organized in Reno County but did not have a building until 1875. The church on this card was the second of three used by the congregation. It was dedicated in 1908 and lasted until 1970, when it was torn down and replaced by the current structure.

Originally formed as People's Congregational Church in 1888, this church first stood at the corner of Fifth Avenue and Main Street. This location later became the Stamey Hotel (later the Landmark Apartments). The church on this post card at Eleventh Avenue and Walnut Street was built in 1910. The congregation moved again in 1969 to North Plum Street, and the building was sold. It still stands today and is in use as a residence.

Church of the Brethren was a Dunkard church first established in 1892. For many years, the congregation borrowed a building from the Seventh Day Adventists on Second Avenue and Poplar Street. In 1911, after the Adventists moved, the Brethren decided to build their own church. The congregation moved on from this building in 1959, but it sits at the corner of Eighth Avenue and Ford Street to this day; although no longer a church, it found a second life as a residence.

First Presbyterian Church was one of the earliest congregations in Hutchinson. The charter was signed by C.C. Hutchinson and E.L. Meyer, the founder of the town and one of the earliest settlers. Formed in 1872, the first church was a simple structure on the corner of Sherman and Poplar Streets. In 1888, this brick building was finished, and the first services were given. The church still stands in the same location, although additions were made in the 1980s to enhance the front entryway, and the building was extended to the south.

First Presbyterian Church had tremendous growth in the early 1900s, and the members decided to create an auxiliary church. Irwin Memorial Chapel was named after A.F. Irwin, who was then pastor of the church. Built on the corner of Fifth Avenue and Severance Street in 1907, it eventually became its own independent church in 1909. The last mention of it in Hutchinson newspapers was in 1912 following the announcement of a wedding.

Swedish Lutheran Emanuel Church was dedicated in November 1888 at the corner of Avenue C and Plum Street. Hutchinson had enough Swedish immigrants for this church to hold services in both English and Swedish. In 1919, a parsonage was bought one block to the north on Avenue B. Several years later, it was decided that the parsonage would be removed and a new church built on the lot. The second church on Avenue B and Plum still exists today as Grace Christian Church.

ST. TERESA'S CATHOLIC CHURCH, HUTCHINSON, KANS.

St. Theresa's Catholic Church first found a home at the corner of Second Avenue and Maple Street in 1878. The lot was given to the church by C.C. Hutchinson. In 1898, Reverend Heitz purchased lots at the corner of Fifth Avenue and Poplar Street. The wood church was moved and stood there until 1909, when construction on the present-day church began. It was consecrated in 1911. The church has undergone several renovations and restorations over the years, including the addition of the Catholic school next door in 1950. Today, the church is still active and is listed in the National Register of Historic Places.

Hadley Church was started by Levi Hadley at the urging of his wife, Mary. The couple were among the earliest settlers in the county, arriving in the fall of 1874. As part of the Women's Christian Temperance Union, Mary was instrumental in getting Reno County declared a dry county. By the late 1880s, she believed that the workers on the south side of town needed a church. In 1890, the building was dedicated at the corner of F and Elm Streets. Hadley Methodist Episcopal Church underwent changes starting in May 1911. The building was enlarged to nearly twice its original size. The central bell tower was also changed substantially. It was rededicated in October of that year.

42

The Evangelical church congregation was established in 1890. The first building was purchased from the Baptist church, but this one was built in 1912 at the corner of Jefferson Street and Tenth Avenue. Tenth Avenue United Methodist Church took over after 1968.

This photograph shows the Christian Volunteer Workers, a short-lived charitable group, around 1912. The leaders of the organization all gave themselves military designations even though none were actually veterans. County attorney E.T. Foote took steps to keep them from soliciting funds, claiming they were a cult. After public opinion turned against them, most of the leaders dispersed throughout Kansas.

The Kansas State Reformatory's history starts in Hutchinson in 1886. After a report by the Industrial Reformatory Commission, Hutchinson was selected as a place to help young men and boys. The goal was to educate and reform them without exposing them to hardened criminals in general prisons. Col. John Severance came to Hutchinson in 1885 and managed to organize community support, find land, and begin construction on many of the buildings for the reformatory. Today, the reformatory sits on the street named after him, Severance, a major thoroughfare through Hutchinson. This photograph shows the field within the walls where baseball games and other activities took place.

One of the goals of the reformatory was to teach young men a trade. Z.R. Brockway, considered the father of the modern reformatory, said that in prison the motto was "be good." But in the reformatory, the motto is "be good for something." The reformatory offered skills to the young men there, such as blacksmithing as seen in this photograph taken around 1910, when gasoline-powered vehicles were slowly replacing many things blacksmiths produced.

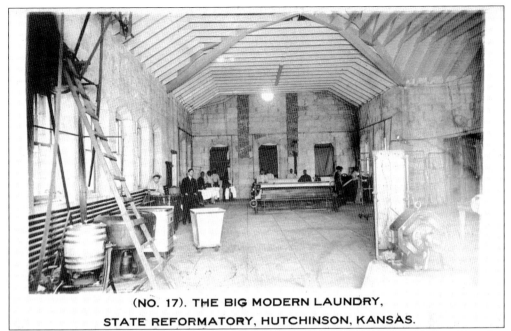

(NO. 17). THE BIG MODERN LAUNDRY,
STATE REFORMATORY, HUTCHINSON, KANSAS.

As with all reformatories and prisons, there is a laundry. This one touts being a "modern" laundry. Mechanized washers and dryers are evident. Another fact worth noting is that of the 12 men in the photograph, 10 of them are African American. It is possible that the specialized trades were reserved for white inmates, while black inmates were relegated to menial labor-based jobs.

Marion Bailey was given extraordinary access to document the reformatory. There are almost two dozen photographs in his series, like this one. It may be devoid of people, but the prep work prior to the meal being served shows how regimented life was. Every plate has a sandwich, and every row has a large pot of beans and a drink to be passed down. Even the utensils are laid out in a similar fashion. The tables and chairs are simple and almost certainly were made on site by the inmates.

Picking Cherries Ks State Industrial Reformatory Hutchinson

While the focus of this photograph is the men picking cherries, the real story is the guard on horseback. Reason Sherman Monroe began his career at the reformatory around 1904. After leaving in 1924, he became the first Hutchinson police officer killed in the line of duty. He responded to a domestic disturbance call where the husband had fled the residence with his young son. Monroe found and confronted the man a short time later. The man pulled a gun and shot Monroe three times. Monroe never even drew his weapon for fear of hitting the boy, and he died the next day.

(NO. 13). PLOWING THE TWENTY ACRE POTATO PATCH, STATE REFORMATORY, HUTCHINSON, KANSAS,

The reformatory strived to be self-sufficient. Around the complex were a variety of fields for farming produce and other consumables. The men in this photograph are farming the potato field that would go to feed the men inside.

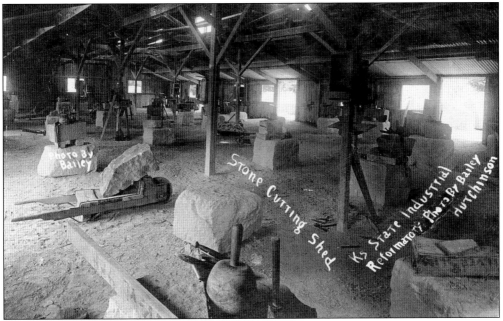

Stone cutting served two purposes at the reformatory. The men would learn a valuable skill in masonry that has always been in high demand. The other reason is that most of the stones in this picture would have been used for construction or repair on site. This provided the men and the prison with a practical way to use their skills. Note the wheelbarrow with the large stone awaiting cutting.

Barber Shop
KS State Industrial Hutchinson KS
Photo By Bailey

Even inmates need a barber. This was also a skill that could be applied once released back into the public. The photograph also offers a glimpse into the layout and necessities of a barbershop around 1910. It is unknown if the man in the image is an instructor or an inmate.

(NO. 3).TRADES SCHOOL BUILDING,
STATE REFORMATORY, HUTCHINSON, KANSAS.

This building was once located on the grounds of the reformatory, just southwest of the cell blocks. The trades that were taught there are unknown. However, for the last 130 years, the trades and skills taught on the grounds have included animal husbandry (primarily chickens), tailoring, broom making, printing, shoe repair, cabinet making, and electrical work. Inmates were also required to attend church on Sundays, with classes taught by volunteers from the community.

Home Office of The Great American Life Insurance Co., Hutchinson, Kansas
"WE CAN SERVE YOU BEST"

The Great American Life Insurance Company building at 100 South Walnut Street was constructed in 1917 at a cost of $60,000. At the time, the company boasted that it was "the only company incorporated under the laws of this state that will own its own office building." Great American Life moved into the first floor and leased out the second floor, including to KWBW through the 1930s and 1940s. It sold the building in 1958 to Bankers Investment Company, which then sold it to William Kline in 1965. Kline operated his insurance company from this location until he retired in 1985. The Reno County Museum purchased and renovated the building in 1986 and continues to operate from this location.

Walnut Grove School was in northwest Reno County near the border with Rice County. In this picture is the entire student population on the playground, which consists of a handcrafted seesaw. Note the age range of the children; they were all taught in the same one-room school.

Located near Plevna, this was the Huntsville School around the time of its construction in 1916. For several years around this time, the school had a fine basketball team. In 1916, they won the Reno County school tournament. Huntsville also was the first school in the county to create a Junior Red Cross Society to send aid to soldiers in World War I.

As transportation methods became faster and roads were improved, school districts began to increase in size as one-room schools were absorbed by larger, centralized schools. In 1920, Haven consolidated several schools throughout the nearby townships and a new school was built. Touted as being one of the most modern, the school district was especially proud of the auditorium that could "entertain the most classical of dramatic companies," as reported by the *Hutchinson News*. The school was fully plumbed and electrified, with unified wall clocks. It had science labs, workshops, and home economics kitchens.

This schoolhouse in Arlington was one of the largest outside of Hutchinson. It contained four rooms and had two halls. The school bell was donated by a doctor who brought it from New York. Built in 1886, it lasted until 1912, when it was condemned. On stormy days, the teachers would dismiss class, as the building was so unstable it would actually move with the wind. Cracks in the walls were filled with books and coats to keep out the cold.

Four of Hutchinson's Eight Public School Buildings—Fourth Ave., Allen, Ave A and Sherman St

Throughout the years, no school in Reno County has been spared demolition when it could no longer meet the needs and standards of the growing student population. The top school, Fourth Avenue, was on the northwest corner of Fourth Avenue and Pershing Street. Built in 1889, it was razed when McCandless replaced it. Avenue A (left) and Allen (right) Schools still exist today, although both were demolished and rebuilt as modern structures in the 1950s. The bottom school, Sherman, was the first built in Hutchinson in 1874. It was replaced in 1915 and again in 1981.

At the top is Hutchinson High School, built in 1910. Throughout most of the 20th century, it was a central fixture in student life. After 1930, the campus also housed classes for Hutchinson Community College. It closed in 1983, and four years later, while being demolished, it caught fire. The building then sat vacant and half-destroyed until it was finally pulled down in 1994. Northside School (left) was built in 1910, and after being razed in 1979, became Faris School. Central School was at the corner of Fifth Avenue and Maple Street. Maple Street School has now become Lincoln Elementary.

This school in Castleton replaced the original single-room school in 1904. By 1906, it was expanded to two classrooms and two teachers. The classroom addition is the right half of the building. The front entrance was not altered during the remodel. The small building in the distance to the left is the outhouse for the students. The school was demolished in 1914, and eventually, Castleton School District was folded into Hutchinson.

Home of The Salt City Business College of Hutchinson, Kansas, and group of students representing about one-fourth of the yearly enrollment

The Salt City Business College can trace its roots back to the first decade of Reno County in 1879. Originally at 122 North Main Street, it moved several times before arriving at the northeast corner of Walnut Street and Avenue A in 1916. Classes taught there centered on bookkeeping, dictation, and other business-oriented subjects. The classes were held on the second floor, while the first floor was rented to various businesses. The college operated profitably until 1980, when it finally closed its doors.

This was the third school to serve the students in the Haven area. The first was built in 1887 and was a simple wooden one-room structure that lasted only one year. The following year, a two-story brick building was erected using funds raised by the community. The growth of the community was so dramatic that the building had to be replaced again, by this one, in 1904. Unfortunately, it burned to the ground in 1909. What is most noticeable in this image is the wear pattern on the exterior of the building by the front entrance, undoubtedly caused by the countless children going in and out. Even the door shows wear at a similar height as the walls.

Y. M. C. A. BUILDING, HUTCHINSON, KANSAS

Although founded in 1876, the YMCA had a rough start in Hutchinson. It was not until 1909 that it was given a proper building at First and Walnut Streets. For the next 50 years, it served the community in this location. In 1946, this YMCA was the only one in a five-state area that had fully racially integrated activities. By 1959, time had caught up to the building, and it was determined that it would cost more to fix it than to sell it and move on. The YMCA moved to a new building and continues to provide an important community service in Hutchinson.

Hutchinson Water Light and Power was on Cow Creek at Sherman and Adams Streets. The company was established in 1886, and supplied hydroelectric power by the following year. This was quite a feat, considering that commercial electric power had only been available for less than 10 years nationwide. The city contracted to have 10 city lights powered at a cost of $100 each per year. By the end of the 1800s, plans had been made to rework the horse-driven street cars into cheaper electric ones and Hutchinson continued its growth as a major commercial center.

Works Progress Administration funds arrived just when Hutchinson needed them most. In 1933, Mayor Burt was trying to secure funds to build a new fire station and jail. The city hall building on West Sherman Street was in such a state that "the buildings would be condemned were they not owned by the city," according to the *Hutchinson News*. After two failed attempts to pass the necessary bonds to fund construction, it was finally approved at the end of 1934. In 1937, the building was opened and ready for use. The building still stands at Avenue B and Walnut Street, although its days as a fire station ended in 2016.

This was the second courthouse built in Reno County. Located on the southeast corner of Avenue B and Main Street, it was completed in 1900. The following year, Emerson Carey built a salt plant next door, and for the next 20 years, his brine pump contributed to the success of the salt industry. Unfortunately, this operation compromised the foundation of the courthouse. It quickly deteriorated, and was condemned in 1928. Due to the young age of the courthouse, public opinion quickly turned against Carey. After being sued by the county, he bought the building and the land and had the courthouse razed.

H-4188 Reno County Court House, Hutchinson, Kansas.

The third Reno County Courthouse is at the corner of First Avenue and Adams Street. Completed in 1931, it is a prime example of Art Deco design. The building process through the early years of the Great Depression was a challenge, yet allowed many men to continue working. The courthouse still retains much of its original design, including walnut trim throughout, and very little has needed to be renovated or remodeled inside. It also still retains its prisoner elevator.

The Hutchinson-Kansas Salt Company was located at 18 East Sherman Street. That places the fire engine from Station No. 2 in front of the *Hutchinson News* building, which was across the street. It is possible that this photograph was taken shortly after the delivery of the engine, and the newspaper wanted a photograph. The first fire station in Hutchinson was about 50 feet down the sidewalk to the right, although by the time this photograph was taken, it had been closed for 10 years.

The second fire station in Hutchinson was leased at 12 West Fifth Avenue in 1908. It was decided at that time that the fire station would also receive the first motorized truck. This photograph was probably taken around that time. Note the chains on the tires, which would have helped the truck navigate the unpaved streets.

NINETY HORSE POWER FIRE TRUCK, HUTCHINSON, KANSAS.

Fire House No. 3 was built in 1912 on South Main Street, and this engine was procured for it. Oddly, the men are parked in front of House No. 2 on Fifth Avenue. While Station Nos. 2 and 3 were equipped with a motorized engine, Station No. 1 continued to have a horse-drawn wagon for several more years before the entire department was motorized in 1914. Minor Rexroad is behind the wheel, with Chief Joe Bennett sitting next to him. The other two are D.E. Bertram (left) and William Rickart.

The Hutchinson Sports Arena was completed in 1952. Interest in a large sports arena was based on the economic impact the National Junior College Athletic Association tournament had on the city when it was first held in 1949. After that, it was decided a permanent location was needed, and in 1949, Foy Construction began to build the complex. Since then, the NJCAA tournament has been held annually in Hutchinson.

Methodist Hospital and Nurses' Home
HUTCHINSON, KANSAS

AN ACCREDITED SCHOOL OF NURSING.

The building on the right originally started as the Stewart Hospital. Richard Stewart built the new hospital next door in 1909. The original building then became a school and residence for the nurses who worked at the hospital. Stewart sold the hospital to the Methodist church in 1915, which then changed the name to Methodist Hospital, later Grace Hospital.

Stewart Hospital Hutchinson Ks. By Bailey

James and Richard Stewart were the first full-time doctors to arrive in Reno County in 1881. James was a surgeon and Richard was an ear, nose, and throat specialist. They purchased this home in 1896 and moved out of their original location at 119 West Tenth Avenue. James died in 1907, and in 1909, Richard constructed a new hospital next door. This building became the school and home for nurses.

St. Elizabeth Mercy Hospital, Hutchinson, Kans.

Community involvement raised $100,000 in 1917 to construct St. Elizabeth's Hospital. The building finally started in 1919 at Twentieth Avenue and Monroe Street. The extension of streetcar service to Seventeenth Street and the hospital prompted the city to quickly pave the street. The windows on the top floor to the right were a sunroom to help patients recuperate. The hospital still stands, although it now contains several additions that were put on in 1951 and 1953. Several attempts have been made to convert these buildings to apartments, but to no avail.

In 1925, the original Stewart Hospital building was torn down and a new addition was made that doubled its capacity. At this time, Methodist Hospital was renamed Grace Hospital. Grace also continued the nursing school that was started in 1909 by Dr. Richard Stewart. In 1959, the building with the white railing was torn down and the Rowland Memorial Wing was built. In 1972, Grace and St. Elizabeth's Hospitals merged to form Hutchinson Hospital. The Rowland Memorial Wing and the addition on the right were demolished in 2010.

The first Hutchinson library was built in part by a grant from Andrew Carnegie in 1902. The land at Fifth Avenue and Main Street was donated, and with the grant matching the $15,000 raised by the city, construction commenced. The library was finished in 1904, and a librarian was hired to help curate the 500 volumes donated by the community. Over the next 50 years, the library grew to over 45,000 volumes. It moved in 1951; today, this building houses the Union Labor Temple.

The second and current Hutchinson library was completed in 1951 to great fanfare. Former US president Harry Truman came to see it unveiled at Ninth Avenue and Main Street. Since then, the library has undergone several renovations and expansions. It has continued to expand its outreach programs and technology access, with a total volume count in excess of 200,000.

Post Office, Hutchinson, Kans.

The first post office was a small wooden shack on Main Street. C.C. Hutchinson shared the back half of the land office with the sorting cabinets. In 1907, construction finished on a formal large-scale brick building that sat at Sherman and Walnut Streets. Less than 35 years later, the post office moved, and this building was demolished in 1965.

The current post office was completed in 1940 on the corner of First Avenue and Poplar Street. Over the years, it has undergone several renovations and additions. Inside, its walls contain a mural by Lumen Winter called *Threshing in Kansas*. The competition for the privilege to paint was fierce and ultimately determined by a committee. Winter submitted two paintings, and the one chosen was criticized as not representing enough of Hutchinson's history. Today, however, the painting is listed in the National Register of Historic Places.

AUTO- STREET SPRINKLERS HUTCHINSON K?
 PHOTO-BAILEY

Before the roads were paved, dust kicked up by carriages and automobiles was a real threat to the health of urban citizens. This photograph shows the Shipp Sprinkling Company using Rapid brand trucks procured from the Holdeman Company. Holdeman likely gave the company a discount on these vehicles in exchange for advertising space. Probably pictured around 1910, these men provided an essential service that slowly began to vanish as more streets were paved during the early 20th century.

CONVENTION HALL AT HUTCHINSON, KAN. 60.

Convention Hall was constructed in 1911. City leaders recognized the need for a great venue to attract musicians, theatrical performances, and other events. Pres. William Howard Taft even came to help lay the cornerstone. For a time, the building also housed the city manager's office and other various municipal administrative offices. Renamed Memorial Hall in the late 1990s, the exterior has not changed much over the years. There have been efforts to both demolish and save the building. Today, it continues to hold events throughout the year except in the summer, as it has never been equipped with air conditioning.

This shot of Cow Creek shows it running under Memorial Hall. Even today, the creek is accessible through a system of trapdoors inside the building. To the right is the Rosemont Apartment Building, built in 1913. Today, this building still stands as part of the Reno County Museum. The back 40 feet were removed in the 1980s to create space for a courtyard, but the rest of the building's exterior remains largely untouched.

Three

HOTELS AND BANKING

First National Bank originally started out as Reno County State Bank before the name was changed in 1884. E.L. Meyer became the first president after selling his drug store and moving into the financial sector permanently. On the left side of this post card is the smokestack for the Hutchinson Power Plant, built in 1887. The automobile has been added in after the fact, as the carriages in the background were still more common in the county at the time the photograph was taken.

First National Bank has been on the corner of First Avenue and Main Street since 1876, making it one of the oldest businesses in Reno County. This was the second building to house the bank and was completed in 1911. It was designed by famed architect Daniel Burnham who went on to create other illustrious structures, such as the Flatiron Building in New York City. The building was replaced in the 1970s with the current structure, which still houses First National.

THE NEW RENO HOTEL, HUTCHINSON, KANSAS.

The original Reno House (pictured on the cover) was the first hotel built in Hutchinson in 1871. It stood on the corner of First Avenue and Main Street until it was replaced in 1913 by Charles Conklin. He predicted that the city would continue to prosper and had an extra-thick foundation laid to allow for the expansion of the building to four or even five floors. New Reno Hotel moved out in 1921 to take over the Coliseum Hotel one block to the west. The State Exchange Bank moved in, added a fourth floor, and operated here until 1961.

Pub. by The Rorabaugh-Wiley Dry Goods Co., Hutchinson, Kans.

MIDLAND HOTEL, HUTCHINSON, KANS.

Midland Hotel was the largest hotel in town when it was completed in November 1888 on the northwest corner of Second Avenue and Main Street. For the next 50 years, it operated profitably, although it changed hands numerous times. Businesses operated out of the first floor, and the proximity to the Santa Fe depot kept it busy. Frank Wolcott purchased the hotel in 1924 for $70,000. In 1931, it was condemned and torn down. Wolcott then built a new office building on the lot.

175 rooms — Distinctively Furnished
Good Food at Reasonable Prices
Baker Hotel — Hutchinson, Kansas

Before the Baker Hotel was completed in 1954, another hotel stood at its location at 17 East Second Avenue, the Baldwin. It later became the Brunswick and finally the Midland (not to be confused with the Midland Hotel on Main Street). The Baker was built as a state-of-the-art hotel with telephones, TVs, and air conditioning. It struggled through various owners and remodeling efforts in the 1970s. In 1982, the building was transformed into the Plaza Tower apartments.

The Chalmers Hotel, built by Edward Colson, opened in 1911 at 213 North Main Street next to the Santa Fe tracks. Colson also operated the Midland Hotel. His brother Emery started as a bellhop at the Midland and eventually worked his way up to owner of both the Chalmers and Midland after buying a controlling interest from Edward. The hotel had 170 rooms on four floors with 34 bathrooms. In 1968, the structure was razed for a parking lot.

COLISEUM HOTEL, HUTCHINSON, KANSAS

When the Coliseum Hotel was built in 1908, the newspapers announced that it was the most modern building in a European style. Located at 24 West First Avenue, the hotel also boasted a saltwater swimming pool, kept full by a well 740 feet deep that supposedly could cure a host of ailments. Later, the New Reno Hotel moved into the location in 1921 and remodeled the building. John Graber took control of it in 1930 and turned it into a furniture store. The top two floors continued to run as a hotel. Sadly, the well caused the destruction of the building, as natural gas seeped up from the ground in 2001, causing an explosion. The structure burned to the ground.

Following his brother Edward to Reno County in 1913, Emery Colson started as a bellhop at the Midland Hotel and eventually became the proprietor. Later, he bought a controlling interest in the Chalmers from his brother and started a third hotel, the Leon. It was built in 1929 at 14 East Second Street and named for Leon Nussbaum, who owned Star Clothiers and the block on which the Leon sits. The building still stands today.

H-3182. **Hotel Stamey. Hutchinson, Kansas.**

The Stamey Hotel was built on the corner of Fifth Avenue and Main Street in 1923. Contractor A.R. Barnes said that when the concrete was poured, it was covered with tarps and then a large bonfire was built at floor level to help in the curing process. Although slated to be opened that spring, it was nearly the end of summer before it was ready for the public. In May 1958, the 125 rooms began to be converted to apartments, and the name was changed to the Landmark Apartments to capitalize on the fact that the building was a local landmark. It closed in the late 2010s.

THE STATE EXCHANGE BANK, HUTCHINSON, KANSAS.

After the New Reno Hotel moved out in 1921, the State Exchange Bank took over the building at First Avenue and Main Street. A fourth floor was added, and the entire building was remodeled. The bank operated out of the first floor, while the top three floors were offices. The De Luxe Theater opened next door and had seating for 640 people. Sometime between 1929 and 1930, the De Luxe was renamed the Strand Theater, and the entire façade was remodeled. In 1961, the theater went out of business. Three years later, it was renovated again. This time, a bulldozer was driven through the front of the building clear to the stage at the back, making quick work of that part of the process.

State Bank of Haven was established at the corner of Main Street and Kansas Avenue in 1894. "Ed" is Edwin Sawyer, who lived in Hutchinson at 104 South Ford Street in the Whiteside Historic District. After 20 years at Monarch Mills, the Sawyer family moved briefly to Los Angeles in 1925 to support Ed Jr.'s movie career until they returned around 1927. After that, Ed Sr. became president of the Haven Bank until his retirement in 1947. Augustus "Gus" Myers worked in various roles at the bank, including vice president for 17 years.

Four

AMUSEMENT

The Hutchinson Larks were a minor league farm team for the St. Louis Cardinals. In 1935, an oil boom created a severe shortage in hotels and boardinghouses and prompted manager G. Carl Hipple to make an appeal to the community to help him find a place for his 50 players to stay. In April, the team lost an exhibition game against the Kansas City Monarchs, the champions that year in the Negro baseball league. Herb Bremer (second row, far right) was drafted by the St. Louis Cardinals and played for them from 1937 to 1938.

When the country club building was constructed in 1905, it was on the outskirts of town. The following year, the Hutchinson Chemical and Alkali Company built a massive factory next door. The soda ash and other chemicals killed all the nearby vegetation and destroyed the golf course. Emerson Carey ran the chemical company and was a member of the country club. In 1920, the building was bought by the plant, and the club moved to a new location—closer to Carey's home.

HARDING MEMORIAL, HUTCHINSON, KANSAS

In 1923, the Harding Memorial was erected on Fourth Avenue to commemorate the president's visit to Hutchinson. This photograph shows French 75mm field guns within the memorial. The guns were used to signal Harding's arrival in the city, and commemorated the 35th Artillery Division in World War I, which was comprised of a substantial number of Kansas soldiers. The guns were lost to a scrap metal drive in 1942.

This composite photograph was printed by photographer Sam Hirst in 1907. It shows Howard Ellsworth Wood ("H.A. Wood" was Hirst's mistake) on his first professional team. He joined the Boston Red Sox the following year and picked up the nickname "Smoky" based on the speed of his "smoking" fastball. In 1912, he led the Red Sox to a World Series victory by winning three of the four games he pitched in. He had a natural talent for baseball, playing from 1908 to 1922, and was inducted into the Red Sox Hall of Fame in 1995.

At the turn of the 20th century, baseball was king in Reno County. Churches, businesses, and schools often played against each other. This photograph was taken in 1912 of the Foundrymen who represented Hutchinson Foundry and Machine Works. Another team known as the Eagles was formed this year. They dominated the league, winning 80 percent of their games and over half the team batting over .300.

On April 14, 1911, the first exhibition of an airplane was held in Kansas. The monoplane in the photograph was a revolutionary design for the time. Three pilots made three flights showcasing the new invention. One flew off until the aircraft was a mere speck on the horizon. Another climbed several thousand feet, cut off the engine, and performed a silent landing in front of the crowd. The speed demonstration featured a race between the plane and a Chalmer's automobile that resulted in a loss for the plane. Two years later, John Bixler became the first aviator in Reno County after training under the Wright brothers in Ohio.

The NEW Kansas Cosmosphere will become a reality . . .

The Kansas Cosmosphere and Space Center—or simply, the "Cosmosphere"—has been in its current location since 1966. Started by Patty Carey, it had humble beginnings at the Kansas State Fairgrounds in 1962. The museum has undergone several major renovations and upgrades since it found a home on the grounds of Hutchinson Community College. The postcard above shows an early artist's conception of what the museum would look like following the renovation through the late 1990s. While there are several differences versus what was done, all of the major components can be seen at the museum. These include an SR-71 Blackbird in the lobby, authentic Mercury and Gemini rockets, and a rocket engine outside. The postcard below shows the museum as it was in the early 1980s. By then, it had developed into a nationally recognized premier space museum. Not only did it contain astronautical artifacts, it had educational programs aimed at all ages designed to encourage scientific knowledge. The Cosmosphere is now an international destination for all space enthusiasts and researchers.

Hutchinson, Kansas

THE KANSAS COSMOSPHERE & SPACE CENTER

CAREY PARK HUTCHINSON, KAN. 56.

Constructed in the 1930s as a Works Progress Administration Project, the boathouse at Carey Park was built from metal from illegal stills that had been confiscated and melted down. As the park expanded in other areas, including a new water park, there was less demand for boat rentals, and the boathouse showed signs of neglect. In 2012, the structure had succumbed to the ravages of time as the shoreline began to erode the foundation beneath it. After demolition, the limestone was recycled throughout the park.

EMERSON CAREY MEMORIAL HUTCHINSON, KAN. 37.

The Carey Memorial Fountain was first lit on July 2, 1935. More than 500 vehicles gathered to watch the lights illuminate the spraying water. "For an hour and a half, the water designs and colors changed so that no moment was exactly like another," reported the *Hutchinson News*. From dusk until 10:00 p.m., people would gather for sometimes an hour or more just to enjoy the show. In 1952, the structure was moved to a new prominent location to allow the construction of flood control measures along the Arkansas River.

Pub. by The Rorabaugh-Wiley Dry Goods Co., Hutchinson, Kans.
BIRDSEYE VIEW RIVERSIDE PARK ROLLER COASTER.

Riverside Park was located on 50 acres at the end of South Main Street bordering the Arkansas River. It contained an amphitheater, zoo, amusement park, and baseball fields. The park was extremely popular, with a variety of vaudeville acts performing and occasional fireworks shows. This photograph was taken from the top of the Circle Dip rollercoaster; one can see the tunnel where the ride starts at the bottom. Competition from Carey Park next door and the Great Depression eventually closed the park in 1932. After a flood control system was built over the site in the 1950s, nothing of the park survives today.

K.C. "Koon" Beck was born in Nickerson in 1875; he bought Riverside Park in 1909 and began to expand virtually every aspect of it, especially the zoo. Beck was a naturalist who loved animals and managed to procure animals from all over the country and sometimes from overseas. He had ostrich, buffalo, mountain lions, chimpanzees, and more birds than could be counted. At one time, Beck operated the largest zoo in Kansas and one of the largest on the plains. This photograph shows the waterfowl preserve near the center of the park.

Steven's Pond was in use as early as 1896. For most of its existence, there were three separate pools. By the 1940s, they had all merged into one. The pond closed in 1948, only to reopen again in 1954 as Baumhard Pool. It was closed again in 1958, but the Moose Lodge bought it and operated the pool until 1980. Today, the pool is filled in, although the clubhouse foundations remain at Lorraine Street and First Avenue. If the water slide in the center of the bottom photograph looks dangerous, that is because it was—one person was killed on the slide in 1909.

In 1910, the Salt City Business College football team had only four men who had ever played the game. After a rather substantial loss, their coach, Professor Thayer, remarked, "I just picked them out on their looks. The lineup will be entirely changed for the next game." While their final record that season is unknown, the newspaper reported that their performance improved greatly throughout the year. Behind the men, the white top of the Home Theater and the spire of the county courthouse on Main Street can be seen.

The fair was a fantastic way to get products noticed. New technologies were introduced, and farmers could plan which innovations they wanted to take advantage of. These salesmen of the Althouse and Wheeler Company were probably based in Hutchinson and are showing their latest models of windmills. The company was started in 1874 in Waupun, Wisconsin, and sold windmills all over the plains and even to overseas dealers.

International Harvester was still in its infancy in 1908. The friction drive tractor in this photograph was the first model produced by the company, from 1906 to 1910. The tractor was considered state-of-the-art at the time, but due to speed and maneuverability, it was rarely used to plow fields. Instead, its powerful gasoline engine was used to operate belt-driven threshers and other farm equipment.

Four years after the Wright brothers made their historic first powered flight, *Sunflower Airship 1* arrived at the Kansas State Fair in 1908. About 3,000 people showed up to watch as the only airship company in America delivered the first flying machine to Kansas. On September 15, the crowd watched the airship take to the sky. The *Hutchinson News* reported that all the skeptics in attendance who claimed that powered flight was fake were quickly silenced.

Marion Bailey took this photograph of the southern section of the racetrack at the state fair around 1910. In the 1920s, aircraft became common enough that the stables on the left were torn down and a small airstrip was constructed. For over a decade, this was a popular landing spot during the state fair. Bailey claimed 35,000 people in attendance. This accurate estimate is even more impressive when one realizes the population of Hutchinson was less than 17,000 in 1910.

"We were here today, 1912," remarked the sender of this photograph. The stables were on the northern end of the state fairgrounds right next to the racetrack. After 1915, a small track was constructed between the buildings to allow horses to walk during the day without having to use the main track. Later, all these structures were torn down, and Bison Hall was built on the spot.

Five

INDIVIDUAL ENTERPRISE

Fords are being unloaded at the train depot in Haven, Kansas, in 1915. Fords were often shipped unassembled and would be put together at the depot or a nearby warehouse. From left to right are August Valdois, unidentified, George Merritt, Buzz Hartzler, Loftus Wilson, Frank Caniff, and Otto Tonn. Tonn started a garage in Haven around 1911 where he sold Ford vehicles. It is possible that the six men with him each owned one of the cars in this photograph. August Valdois came to Reno County in 1873 at the age of six with his parents from France.

Willie Tonn (left) and August Meier stand in their hardware store in Haven, Kansas. Tonn, the son of German immigrants, came to Reno County in 1885 with his parents. The picture was probably taken sometime between 1901 and 1905. By 1905, Tonn had purchased a farm south of Haven and spent the rest of his life there. Meier got his start in Haven with the first meat market in town. He married Tonn's sister in 1901, which might have encouraged the two to go into business together.

Located at 2524 East Fourth Avenue, the Hutchinson Refining Company started in 1917 and was owned by F.D. Larabee. In 1919, it changed its name to Hutchinson Petroleum Co. after being purchased by a company based in Omaha, and the location moved to Fourth Avenue and Halstead Street. At its peak, it produced about 1,000 barrels of oil per day and had a storage capacity of 100,000 barrels. The company went under in 1921 due to the high price of crude and its inability to get oil to Hutchinson fast enough to meet demand.

Joe Kern started his garment business in 1908 at 18 North Main Street. It was the first high-end garment house in Hutchinson and catered primarily to women. He moved his store several times before settling at 20 North Main Street. Kern remained in business there for a time before moving to Wichita and then again to Oklahoma, where he became a traveling salesman. Sadly, while driving on one of his business trips in 1929, he suffered a heart attack. Passing motorists attempted to save him, but he died in South Haven, Kansas, at the age of 48.

The Hutchinson Implement Company advertised it was the only firm to handle vehicles and farm implements in Reno County. In 1909, it was located at 17–19 East Sherman Street. These photographs were likely a form of advertisement. The company sold John Deere implements and the Velie automobile at a cost of $1,750, which is over $50,000 today. Carriages are visible through the window above, and the interior photograph below shows a wide assortment of farm implements.

In 1910, J.H. Holdeman sold his share of the Salt City Motor Company and started the Holdeman Motor Car Company at 101–105 East Sherman Street. He was a dealer for the Rapid Motor Vehicle company, which specialized in trucks. Holdeman later landed a contract to supply the city with street sprinklers to help keep down the dust. He left Hutchinson to serve in World War I and never came back, settling in Texas instead.

Albert Foeltzer settled in Reno County in 1887 and operated his cigar and billiards business until he retired in 1927. He had a factory and storefront at 4 South Main Street and later moved to 11 North Main Street and expanded to include a barbershop and billiards area. Just past the counters is a partition where at least four billiard tables can be seen. In 1893, the company stated it manufactured over one and a half million cigars. His store had a tin ceiling and walls, which would have created a dramatic effect on entering the establishment.

Edward and Charles Sidlinger came to Hutchinson in 1882 and bought the drugstore owned by E.L. Meyer. Edward practiced medicine well into his 80s. Charles owned and operated the drugstore. Originally the store was at 3 North Main Street before moving to the north at 11 North Main Street by the end of the 1880s. Along both walls are jars full of compounds used to create various medicines. Charles is likely on the far right, but he and Edward both had long beards, and their similar features make it difficult to tell them apart.

New arrivals to Reno County often came with little more than could be carried in a small wagon. Furnishings were almost always left behind in favor of other necessities. Upon arrival, these items would need to be replaced, creating a high demand for furniture. Model Furniture started in 1906 on West Sherman Street. In 1909, it moved to 8 North Main Street, where this photograph was taken. By 1915, the company had been bought by Bauer Furniture, which then went out of business following a fire that gutted the building.

RORABAUGH-WILEY
BUILDING.
HUTCHINSON, KANS.—4

Few buildings in Hutchinson have been as iconic as the Wiley Building. In 1905, Anson Rorabaugh and Vernon Wiley bought out Patrick Martin's store. Martin had been in business for nearly 20 years in Hutchinson and was ready to move on to California. His store provided an excellent customer base that Rorabaugh and Wiley built on. Rorabaugh and Wiley saw a dramatic increase when they began offering mail order service. By the end of the decade, plans were made to create Hutchinson's premier shopping destination. Originally called the Rorabaugh-Wiley Building, it opened in 1913 to great fanfare. Due to increasing competition from the new Hutchinson Mall, Wiley's went out of business in 1985.

Rorabaugh-Wiley Dry Goods Co
Hutchinson Ks
Front Door Isle Photo By Bailey

Continuing the floor plan set up by their predecessor Patrick Martin, Rorabaugh and Wiley maintained the department store layout throughout the entire existence of the company. This photograph of the new building shows what customers would see as they walked in the front door. Well-stocked cases and a wide assortment of styles made Rorabaugh-Wiley Dry Goods a one-stop shop. After Rorabaugh retired in 1932, the name of the company was shortened to just Wiley's.

CARPET DEPT., RORABAUGH-WILEY DRY GOODS CO., HUTCHINSON, KANS.

The popularity of wall-to-wall carpeting was years away in 1913. The unpaved and dusty streets of most cities made it impractical. Instead, carpets were made to be taken outside and cleaned regularly. Wiley's provided a multitude of patterns and custom sizes, as evidenced in this photograph.

REST ROOM, RORABAUGH-WILEY DRY GOODS CO., HUTCHINSON, KANS.

The mezzanine level of Wiley's contained a tearoom, beauty salon, and restrooms. This photograph shows the various chairs available for use. On the table is a public telephone.

CLOAK-SUIT DEPT., RORABAUGH-WILEY DRY GOODS CO., HUTCHINSON, KANS.

This photograph shows the "cloak-suit" department of Wiley's. Unfortunately, it is not known if this was the women's or men's department. In both, clothing could be tailor-made and customized. This may explain why this was the only clothing department for women on the second floor rather than the first. Keeping them separate could help prevent "accidental" viewings by any stray customers.

MAIN AISLE, FIRST FLOOR, RORABAUGH-WILEY DRY GOODS CO., HUTCHINSON, KANS.

Wiley's operated out of the bottom four floors of the building. In general, as customers moved up from the first floor, the items would be less popular, more expensive, or in lower demand. The first floor contained everyday items such as most kitchen items, jewelry, candy, shoes, and perfumes, as seen here.

MEN'S FURNISHINGS DEPT., RORABAUGH-WILEY DRY GOODS CO., HUTCHINSON, KANS.

Where Rorabaugh and Wiley really excelled was their mail order service. Residents of the county outside Hutchinson were able to have virtually anything delivered to them. This saved on the extended travel times that farmers in outlying areas could not afford to make. This photograph of the men's department shows the massive inventory available. From simple socks to the latest Parisian fashions, Wiley's could get it all and make it accessible in a city less than 50 years old.

Marion Bailey (1869–1944) was quite possibly the most prolific photographer of the early 20th century in Hutchinson. He was a professional photographer from 1905 to 1915 and produced an astounding collection of photographs. His images were used in the newspapers, early souvenir books, and especially postcards, but little is known about his life. He had four daughters, one of whom, Edith, followed in his footsteps for a time. Many of the photographs in this book were taken by Marion, and he deserves much credit for his skill.

Reno County once boasted a great number of orchards. This photograph of the Underwood Orchard shows men picking apples on 40 acres. Cold Kansas winters ultimately sealed the fate of orchards in Reno County. At one point, Underwood even experimented with oil heaters to prevent his trees from freezing during the unpredictable spring frosts. By the 1940s, orchards like this, once located near Orchard and Cone Streets, were gone forever.

The abundance of salt brine in the county prompted the building of the Soda Ash Plant at Eleventh Avenue and Chemical Street in 1906. Soda ash is important for a variety of products such as glass, baking soda, and high explosives, and salt is a vital component of soda ash. The plant struggled under poor management, and with investors getting anxious, Emerson Carey took over in 1909 and completely overhauled the operation. After the company became profitable the next year, he was able to save the investors from financial ruin by selling to the Solvay Company. The plant closed after World War I.

In the early days of the automobile industry, Hutchinson was one of 10 Kansas towns manufacturing vehicles. The Sellers Motor Car Company started at 705 South Main Street in 1909. The company showed modest success, but the arrival of World War I ultimately caused Sellers to go out of business. Rexroad Engineering bought the factory and patents and sold almost everything related to automobile construction. Several investors were left bankrupt as a result. The company only produced around 50 vehicles. As a result of time and the scrap drives of World Wars I and II, none are known to survive today.

The Sellers Model 60 was a massive vehicle by the standards of today as well as then. The tires were about three feet tall, and the car itself was nearly 30 feet long. The vehicle was so large that Bailey struggled to get the entire machine in focus. The back half of the car looks fine, but the front is most definitely fuzzy. This car was likely an early test model, as very few were built.

The Sellers Model 35 was the primary vehicle built by the company. Sellers entered two of this particular model in an endurance race in 1909 that went from Hutchinson to Colorado Springs, down to Pueblo, and then back home. Both cars returned home safely. The first car had a perfect score. The company stated that the second car had come off the showroom floor, without any testing, and ran the fastest time.

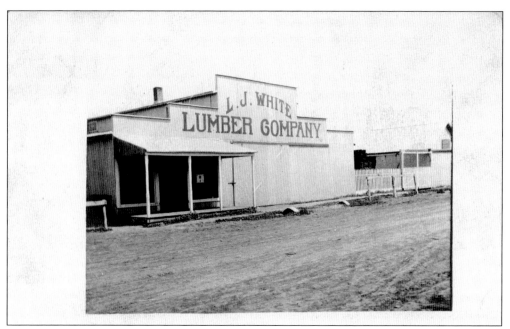

L.J. White opened his lumber mill at 17 West Sherman Street in 1896. Lumber was an important and valuable commodity for a county that, in 1870, was reported by the surveyors to have less than 10 trees. As settlers poured into the county, trees were planted by the thousands. In 1920, White sold out to Sam Hostetler and retired. The lumber mill operated from this location for 85 years before being closed and torn down in 1982.

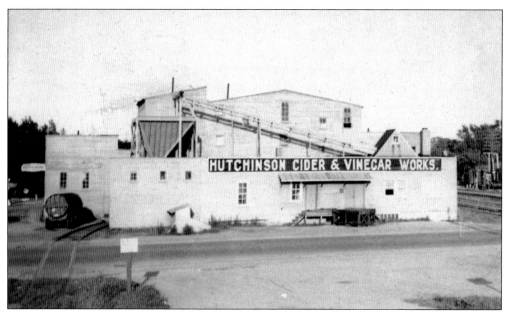

Herman Bernscheidt started the Hutchinson Cider and Vinegar Works in 1902 at 201 East Third Avenue. Apples were big business in Reno County until the 1940s, and the availability of large quantities kept the factory in business. Besides cider and vinegar, it produced pickles, horseradish, apple butter, and a variety of other products. The company closed in 1976.

THE UNDERWOOD & VILES GREENHOUSES. HUTCHINSON, KANSAS

Underwood & Viles was a successful cold storage and produce company at the start of the 20th century. Its greenhouses once sat on the east side of Cow Creek at Eleventh Avenue West. In 1909, there were 16 greenhouses measuring 25 feet wide and 250 feet long. Under these glass roofs, the company grew lettuce, radishes, and cucumbers. Glass buildings are a risky venture with Kansas weather.

Main Buildings and Power Plant, N. W. View.

Cooking Room and Stock Room, N. E., View.

For its first four years, the Western Strawboard Plant struggled. In 1917, salt tycoon Emerson Carey took over as president. He reorganized the company, and soon after, it was turning a profit. At its peak, it was taking in 20,000 tons of straw every year and employed 100 men. In 1947, the plant suffered a substantial fire that cost the company $250,000. It has changed hands many times over the years but still operates today on Halstead Road.

NELSON MANUFACTURING PLANT, HUTCHINSON, KANSAS

HUTCHINSON FOUNDRY AND MACHINE WORKS

These two companies were both involved in the manufacture of machined metal products such as pipes, tanks, culverts, and pulleys. The large building on the left side of the Nelson plant was originally part of the Sugar Mill built in 1875. At Ford Street and First Avenue, it was listed in the National Register, but years of neglect caused it to be demolished in 2019. The Hutchinson Foundry is pictured at its first location at 101 West Avenue B from 1905 to 1913. After that, it moved to Avenue D and Washington Street, where it stayed until a merger closed the foundry in 1972.

With Dodge City and Wichita having established stockyards, Hutchinson was never destined to be a cattle town. However, there was a stockyard in Hutchinson for a time that dealt in pork and cattle. To the right is a building with a sign reading "Hutchinson Packing Co." It was in business in 1887 and directories show it was two miles east of town on Fourth Avenue. The building in the background appears to be the Carey Salt Plant near Lorraine Street and Carey Boulevard, which puts the stockyard on the Rock Island Line.

George Schurr (center left) came to Hutchinson in the early 1900s. Originally a traveling salesman, he set up a greenhouse at 1020 East Sixth Avenue. This photograph shows four of his seven children. After about 10 years in Hutchinson, Schurr continued west with his family and settled in San Diego.

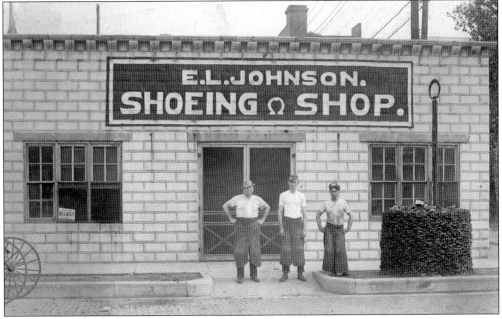

The sign in the left window reads "Vote for Geo. A. Neeley . . . U.S. Senator" and helps to date this photograph to 1914. Neeley was the candidate of choice for Edward L. Johnson. In 1914, Johnson's shop was at 18 West Avenue B. The enormous pile of metalwork to the right is all horseshoes. As motorized vehicles and mass-produced implements began to be more common, the need for blacksmiths began to decline. By 1919, Johnson was the only horseshoe maker in town.

The Taylor Motor Company was founded in 1908 at 23 East Sherman Street. This photograph shows a publicity stunt Taylor put on that year. He drove one of his Chalmers-Detroit cars on a 200-mile endurance and speed race. The sign on the side of the car proclaims the engine has run nonstop for 23,000 miles, likely an exaggeration. Taylor did the driving and took along Will Thompson; Claud Giles, the mechanic; and S.M. Johns, the timekeeper. The entire race was run in a little over nine hours, during which they averaged 26 miles per hour. Taylor sold the company in 1921 to Davis and Childs, who stayed in the business for 50 years.

Six

SALT, GRAIN, AND RAIL

Built in 1887, Bushman and Welk took over the Haven mill in 1902. Business was so good that within three years, they added additional equipment that could grind 900 bushels of wheat every 24 hours and were selling flour as far west as Denver. In 1906, a galvanized iron roof was placed over both the mill and the elevator, as seen here. Welk moved to Russia in 1907 and Bushman moved to California. The mill was sold for $30,000 and became Haven Mill, but closed in the 1920s when the Hutchinson milling industry became dominant.

In the early 20th century, harvesting began to be more mechanized, but self-propelled combines were still a few years off. This is a typical scene of the manpower required to thresh a field of wheat. Joe Canning is the only one identified, at far right. When this photograph was taken in 1914, he was 19 years old. After marrying in 1922, he and his wife moved to Plevna, Kansas, where he was a council member and mayor. He stayed in the farming business until he died at the age of 92 in 1988.

This photograph was taken outside of Abbyville in the summer of 1917. The group is reaping a crop of wheat and bundling for the next phase of threshing on the farm of J. William Heironimus. In 1917, Heironimus had a three-year-old son named Ralph, who could be the young boy sitting on the horse.

This was the interior of the Abbyville Santa Fe Depot around 1910. The operator is listening to the telegraph machine and writing a message. He was responsible for keeping arrival and departure times updated and also coordinated the unloading of freight cars and billing issues. Next to him near the window is the transmitter. To his left are the switches that controlled the rails in front of the depot.

This photograph was taken around 1914 on the Ehling Farm just north of Abbyville. The Ehling family consisted of 11 children, and some are probably in this photograph. With this setup, five men and six horses could reap up to 12 acres a day. The women in the carriage are likely delivering a meal to the men in the field. Even today, those involved with the harvest rarely leave until the work is completed, necessitating meal deliveries.

The Rock Island Railroad reached Partridge in July 1887. The previous year, the Santa Fe line came through and gave Partridge the distinction of having two rail lines. O.H. Smith had the honor of being the first operator of both depots. Hired by the Santa Fe, Smith quit the company in 1887 to run the Rock Island Depot—for a substantial salary increase. In the 1950s, both depots closed as Reno County began to develop better roads and vehicles became more efficient methods of travel to nearby Hutchinson.

Nickerson had a grain elevator as early as 1883. In July 1911, this elevator was built. The warehouse on the left was erected in 1915 to aid in the offloading and storage of grain. Later that year, a new set of scales were installed. The sign on the building on the right advertises "Fairbanks Scales," a company that still makes farm scales today. The elevator changed hands several times before it was finally razed in 1990.

THE GRAIN ELEVATOR AT HUTCHINSON, KAN.

138.

George Gano came to Hutchinson in 1904 to get into the burgeoning wheat trade. He helped found the Hutchinson Board of Trade in the early 1910s. This elevator was built in 1930 by George Gano Grain Company. This picture probably dates to that time, as the row of bins on the right still retains the Gano signage. At the time of the merger, the company was operating 70 grain elevators with over three million bushels in capacity and 15,000 acres of wheat crop. Gano sold his empire to Bunge Corporation in 1947, and the addition on the left side of the tower was added a few years later.

Although Kansas Grain Company started in 1881, it leased an elevator that was built seven or eight years earlier. The elevator was operated by them at 112 West Second Avenue, where massive piles of buffalo bones had been collected to be shipped east. The original elevator lasted nearly 30 years, substantially longer than most similar ones of the time. Fires consumed many of these early wooden structures. By 1915, the company had 20 elevators and was among the largest suppliers of grain in the country.

This photograph highlights the expansive grain industry in Hutchinson at the end of the 1940s. The Santa Fe rail line cuts diagonally across the image, with Avenue A at right, ending in front of Larrabee Mill, which was built in 1908. The Security Elevator Company built the grain elevator

at upper left in 1919; it is the oldest elevator still in use in Reno County. Most of these elevators still stand and are in use today, except for the two on the Santa Fe line.

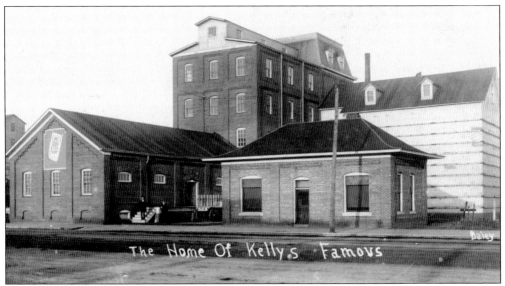

William Kelly built this flour mill in 1906 shortly after leaving Monarch Mill. Ten years later, he added a grain elevator to the mill. The operation continued until 1970, when the mill was closed. Today, only the small office in the foreground on the right remains. At 400 South Main Street, the "K" is still visible on the front of the building, and the massive circular footprints of the grain elevators are still visible. The mill's loading docks are still standing, although they have been derelict for nearly 50 years.

The Larabee Mill is at the east end of Avenue A. Built in 1908, it was considered one of the finest mills in the country. It had 25 pairs of German-made metal-encased rollers, each seven feet tall, that could grind out 2,000 bushels of wheat per hour. The factory ran a 12-foot, 22,000-pound flywheel on a 600-horsepower natural gas engine that ran the machines 24 hours a day. The entire building was made of concrete and metal and was said to be fireproof. In 1915, a 500,000-bushel elevator was added. The mill closed in the 1960s, followed by the elevator in the early 2000s.

L. M. ULMER, PHOTO. ABBYVILLE

Six horses are hitched to a Deering-McCormick reaper, with the largest conveyor available for this reaper, measuring 14 feet. The wagon has wood cribs on either side to allow wheat to be piled extremely high. In the background, a mound of wheat with another wagon and team of horses awaits threshing. The hardships of the Great Depression and the rationing of World War II meant this reaper was still available for purchase in the 1940s.

Barton Salt Plant, Hutchinson, Kans.

PUB. BY HUTCHINSON BOOK & ART CO.

In 1887, one of the largest salt beds in North America was discovered under Reno County, which has shaped the future of the county and the state of Kansas. By 1888, word of the discovery spread, money began to pour in, and within a few years, over a dozen salt plants were built. In 1892, Frank and William Barton organized Barton Salt and quickly built this plant. Located just east of Plum Street on Campbell Street, it was producing 300 barrels of salt per day before it burned to the ground in 1903. It was quickly rebuilt, and in 1973, the plant was purchased by Cargill. Although technology and time have changed its appearance, it still operates in the same spot today.

The first Missouri Pacific Depot opened in 1887 at Main Street and Avenue G. It was almost destroyed by fire in 1895 after some itinerants started a fire to keep warm in a nearby boxcar. In 1900, this new three-story brick building was established on the west side of Main Street and Avenue D. The building was remodeled in 1951, and the top two floors were removed, but 35 years later, it was demolished.

Hutchinson was founded as the Atchison, Topeka & Santa Fe rail line arrived at the Arkansas River. The first depot was a small wooden structure, built in 1872 on the west side of Main Street on Third Avenue. This depot was built in 1897 to keep services on par with rival railroads in the middle of Walnut Street on the Santa Fe line. The depot operated until 1955, when a modern depot was built to the west. In the background, part of the Bisonte Hotel is visible.

SCENE AT THE ROCK ISLAND DEPOTS, HUTCHINSON, KANSAS

The Rock Island Depot opened just a few months after the Missouri Pacific in July 1887. Located on the east side of Main Street and Avenue D, it was replaced in 1951 with the present station, which was constructed a block to the east. The grain elevator to the left was built in 1887 and acquired by O'Neill, Kaufman and Pettit in 1908, which is clearly visible on the side of the elevator. Sadly, it burned to the ground in 1913 after being struck by lightning.

When Fred Harvey came into the railroad business in the early 1870s, he found food and accommodations on the Santa Fe line lacking in style and class. In 1876, he built his first restaurant in Topeka, Kansas. Harvey branched out farther west and moved into building hotels that were designed for the upper and middle-class travelers migrating west. The third floor of

HUTCHINSON, KANS.

the hotel was reserved for the famed Harvey Girls quarters. Thousands of young women between 18 and 30 were well paid and trained to act by a strict but fair code while employed for Harvey. Stories abound about how Harvey personally handled any customers who attempted to harass the women or cause disruptions at his hotels.

The Bisonte Hotel was built in 1908 during the peak construction period of Harvey Houses. Fred Harvey created these elegant and upscale hotels and restaurants up and down the Santa Fe line from Topeka to San Diego. At one point, there were over 80 of these grand buildings providing excellent food and reasonable accommodations across the Great Plains and the Southwest. Harvey and his hotels have been well documented in the United States, and he has been credited as being a contributor to encouraging westward expansion.

The Bisonte Hotel was sold to the American Legion in 1946, and for the next 15 years, it began a slow decline. By the early 1960s, the Legion could no longer afford the badly needed updates and maintenance on the hotel. While there was strong community support to try to save it, the property was sold to developers in Wichita. During its demolition in 1964, the building caught fire and burned to the ground. Although the absence of the hotel is felt by the community, many of its fixtures were saved and are now in the Reno County Museum collection.

CAREY'S SALT. ICE AND COLD STORAGE PLANTS, HUTCHINSON, KANSAS

Emerson Carey began in the coal business as a delivery man. By 1884, he found a partner and began his own coal company. Three years later, he was able to buy out his partner and then expanded into the ice and cold storage business. In 1901, he joined the salt boom and drilled a brine well to begin producing salt. This well was next door to the county courthouse, which ultimately led to its destruction due to the surface instability caused by the well.

CAREY ROCK SALT MINE
HUTCHINSON, KAN.
64

As Carey's salt empire grew, he felt the need for expansion. At the time of its construction in 1910, this salt plant was on the outskirts of town at Lorraine Street and Carey Boulevard. As Carey faced intense pressure over the destruction of the county courthouse, he closed his plant on Main Street in the late 1920s, and this became the primary facility. The plant operated steadily and profitably until consolidation closed it in the 1990s.

The Carey Salt Company Evaporating Plant, Hutchinson, Kansas

The Carey Salt Mine opened in 1923 to much fanfare, including a visit by Pres. Warren Harding. The mine shaft and mill building are on the left. The mine offices are on the right. The packaging building is in the middle. The shaft hoist has been in continuous operation for 100 years, but is set to be replaced by 2023. The salt deposit under Kansas would take over 250,000 years to extract all the usable salt at current rates. In 2007, the Kansas Underground Salt Museum opened.

This image shows the two techniques employed at Carey Salt in the mid-20th century. Brine pumping was used for over 80 years before the plant was shuttered in the 1980s. The mine method required little additional processing other than grinding. When the mine opened in 1923, Emerson Carey had begun to relinquish much of his salt empire to his sons. Today, Hutchinson Salt operates the mine, producing 5,000 tons per day with tunnels 650 feet underground.

SHOWING 2 PROCESSES OF SALT MINING IN CENTRAL KANSAS

THE JOY MORTON SALT PLANT, HUTCHINSON, KANSAS, LARGEST WEST OF MISSISSIPPI RIVER

Joy Morton was a relative latecomer to the salt boom in Hutchinson. He quickly moved in and bought half a dozen salt plants and consolidated everything into one plant. In the early part of the 20th century, Morton and Frank Vincent tried to force Emerson Carey out of business with the use of illegal activity through railroad tariffs. Only when an antitrust lawsuit was brought against Morton by the government was Carey able to resume his business. Though the plant has changed in appearance, it is still owned and operated by the Morton company today.

A common sight in any salt plant is the packing room. Processed salt stands in a pile nearly 30 feet high waiting to be bagged and sent for shipping. Today, much of this process has been mechanized, but when this photograph was taken around 1910, much of the bagging and loading of salt was done by hand. The salt vein under Hutchinson is above 98 percent pure and requires very little filtering.

ABOUT THE ORGANIZATION

The Reno County Historical Society was established in 1961. Three years later, a small informal museum was opened in a house once owned by a mayor of Hutchinson. In 1968, the house was sold to developers, and the historical society had to look for a new home. The old township hall in Haven, Kansas, was offered free of charge and provided a location for the museum for the next 17 years.

By the early 1980s, the building in Haven could no longer properly house the collection and another location was sought. It was during this time that the board of directors decided to incorporate a professional staff along with the volunteer staff. The first director and curator, Michael Knecht and Cherie Cook, respectively, were hired. They spent the next 18 months looking for a location, renovating the new museum, moving the collection, and planning exhibits as the only two full-time staff members. Since then, the Reno County Historical Society has increased its staff and expanded its collection to contain nearly 40,000 items representing 150 years of history. Exhibits and programs have taken full advantage of the wide array of material available to staff.

In the early 2000s, director Jay Smith was given approval to expand the museum to encompass one of the most important aspects of Reno County history: salt. The Kansas Underground Salt Museum opened in 2007 to statewide enthusiasm. Since then, the name has changed to Strataca, but it continues to operate as the only museum that includes a tour of an active salt mine in the Western Hemisphere.

Community support for the museum since 1961 has been unwavering. The robust and comprehensive collection is a testament to the museum's commitment to preserving history and is on par with counties many times the size of Reno County. The Reno County Museum is at 100 South Walnut Street, Hutchinson, Kansas. The website is renocomuseum.org.

DISCOVER THOUSANDS OF LOCAL HISTORY BOOKS
FEATURING MILLIONS OF VINTAGE IMAGES

Arcadia Publishing, the leading local history publisher in the United States, is committed to making history accessible and meaningful through publishing books that celebrate and preserve the heritage of America's people and places.

Find more books like this at
www.arcadiapublishing.com

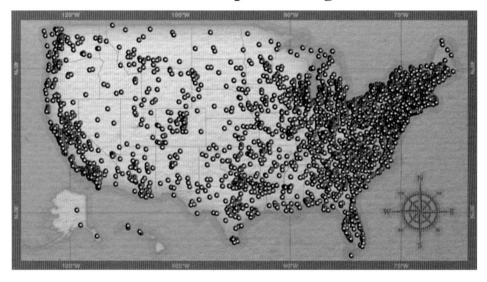

Search for your hometown history, your old stomping grounds, and even your favorite sports team.